Pearl in the Deep Wood

The voice of the living trees

Ruth Finnegan

PEARL IN THE DEEP WOOD

ISBN 978-1-4477-6672-8

2023

KATE-PEARL EPICS, BOOK 5

Callender Press

Old Bletchley

www.callenderpress.co.uk

4

DEDICATION

For Brigid and Kirsten and Kate
of the green living land of New Zealand,
magical

CONTENTS

Preface
15

PART I BEFORE
24

In the beginning was the wood
24

The school
27

In a magical world
30

The great world of learning
32

PART II FLIGHT
33

She couldn't
33

The great secrets
36

But
37

What now …
40

PART III DISCOVERY
41

Africa, a story and …
41

… and a storm
54

PART IV AND NEXT
59

The sun
59

Saved
61

Hot hot
62

Shadows
63

PART V THE TESTS
64

Of informati-on
64

To start again
68

And more
76

The trees themselves
77

Knowledge not-knowledge
82

One …
84

Two
86

Three
87

Four
89

Five
92

Six
94

The seventh
96

The larch
97

PART VI THE SEARCH
101

To finden him
101

Which try?
106

The climbings
107

The infinite of trees
113

There
115

The last?
119

The last, the strongest, best
120

PART VII THE FOUND-NOT-FOUND
124

Would he?
124

And then
126

PART VIII LOST
127

Alone
127

And he
129

Oh no!
130

Farewell
132

The plunge
133

Searching, searching, searching
135

PART IX BACK WAY TO THE SKY
137

Around
137

To reach?
140

PART X THE DARING
145

The possible-impossible
145

Down down and down
148

To dare
151

To leap again.
152

Ending
154

Epilogue
156

If you enjoyed this …
159

Author's Notes
162

Preface

Greetings and, for those who have been with the story before, welcome back.

This is the fifth of the Kate-Pearl epic-romance books: *The Black Inked Pearl, a journey of the soul; The Helix Pearl, the tale of the wine-dark garrulous sea; Pearl of the Wind; Fire Pearl, a tale of the burning way;* and the prequel *Pearl of the Seas.* They are retellings of the age-old myth about a girl rejecting a would-be lover in panic, then searching for him through heaven and earth, desperate to find his love again.

Each is about the struggles of mortal love - or, if you like, of the human soul - interlaced with the eternity of space and time. It can also be read as a parable of the struggles of human beings and their journey through life. In addition each volume, though essentially the same tale, looks at the story from a different perspective, told by a different narrator and invoking a different one of earth's four elements: earth, water, air, fire and, here, following Chinese philosophy, a fifth element: wood, the *living* one.

There may be a further, final, volume with yet another perspective. We will see.

This time the story's teller and perspective is not the single "I" of the garrulous self-centred sea, rich though that narration is, the mystic elusive "you" of the air, the multiplicity of flickering flames, or even the more detached account of searches through the earth in the opening volume, but, here, the plural, active, involved, "we" of living trees. See for yourself which you prefer (you could let me know, if you liked, at www.ruthhfinnegan.com).

This volume continues or, perhaps better put, enlarges and parallels the earlier books in the series. Kate's story recycles, as myths do, in many eras and settings. Here it is through the setting and voices of living vibrant trees; they act as both an encouragement and a challenge for Kate, both an obstacle and an opportunity in fulfilling her destiny.

Surprising as it may seem, the stories arrived with me in dreams - or, more accurately, in that liminal space that is neither sleeping nor waking yet somehow both. This, perhaps inevitably, has resulted in a somewhat

riddling and dreamlike exposition. Like the first of the series, *The Black Inked Pearl*, this volume, and the dreaming from which it sprang, had its origin in New Zealand. The inspiration and about a third of the first volume arose there, while almost all of this one was written during an enlivening three weeks I spent with my daughter there in March 2023. To me New Zealand feels liminal, magical, a spanning-two-worlds setting: both home and not-home, night and day, ice and fire, down under and up over, place at once of new technology and of ancient wisdom.

Behind all the volumes is, unsurprisingly, my own literary experience. This is deeply influenced by my love for the sonic beauty of Greek and Latin literature, Homer above all. So whoever the ostensible narrator of each volume is supposed to be, the style of each is shaped by this personal background, and, among other things, my conviction of the centrality of sound and rhythm in literary expression, and of the continuity of "prose" and "poetry".

This accounts for a style in these volumes that some at first find strange, though, given the works of many established creative writers, scarcely surprising. In the

tradition of prioritising *sound* over currently "correct" grammar or orthography, "Kate", whom I think of as the author, aided by myself, her earthly intermediary, sometimes uses Anglo Saxon / Teutonic endings (*-en*, *-es*), also at times old spellings, when they somehow sound better. The same goes for unconventional extensions, separations and abbreviations of words or their order. Within that framework "new" words and spellings (but perhaps they are old) are deliberate, a play with language and sonic echo - rhythm, alliteration, assonance - allowed, it seems, to poets and verbal artists, as in, for example Gerald Manley Hopkins' sonic poetry or James Joyce's prose. The acoustic poetic dimensions are integral to the style of the novels, influenced throughout by the rhythms and sonic echoing of classic literature, of the Bible, and of African and Irish story telling.

Kate and her mysterious lover's experiences are at times encapsulated in a series of Homeric-like similes, sometimes in direct translation (English is a poetic language too - think Shakespeare, Blake, Milton, Hopkins), sometimes modelled anew on this rightly famous form. Both repetition and the recurrent

epithets characterising Homer's heroes are features of his epic style, up to a point reflected here. So too is the biblical tone in parts of the novel, echoing the nineteenth-century translations in which I first read - and in my mind *heard* - the great resounding songs of Homer.

There are literary allusions throughout the book (surely no literary-fiction writer can escape that), more fully explained in my *Why do We Quote?* They are often echoes of texts learned by heart in my Quaker school. Some of these many allusions - plus some topical echoes as well - are referenced in the Author's Notes at the end, others left to my readers to *feel* (many are deep set, working below our conscious thought), or, if they so choose, to winkle them out.[1]

I hope you enjoy this new story of Kate, caught from the enchanted world of myth and best heard or sung aloud, as she climbs and falls in her search, just as I enjoyed finding it in that magical dream-place between sleeping and waking.

How oft when thou, my music, music play'st,
Upon that blessed wood whose motion sounds
With thy sweet fingers when thou gently sway'st
The wiry concord that mine ear confounds,
Do I envy those jacks that nimble leap,
To kiss the tender inward of thy hand,
Whilst my poor lips which should that harvest reap,
At the wood's boldness by thee blushing stand!
To be so tickled, they would change their state
And situation with those dancing chips,
O'er whom thy fingers walk with gentle gait,
Making dead wood more bless'd than living lips.
 Since saucy jacks so happy are in this,
 Give them thy fingers, me thy lips to kiss.
<div align="right">(Shakespeare Sonnet 128)</div>

<div align="center">
The leaf of every tree brings
a message from the unseen world
Look
Every falling leaf is a blessing
</div>
<div align="right">(Jalāl al-Dīn Rūmī)</div>

<div align="center">
Trees are poems the earth writes upon the sky.
</div>
<div align="right">(Kahlil Gibran)</div>

PART I BEFORE

In the beginning was the wood

We saw her there, we felt and heard, we the trees. At the beginning, we heard the words of the road she had to tread.

We, who were there at the first, we heard, we saw.

She was in the wood from the beginning. In the womb. Her mother's womb. Her mother. Kate's.

We saw the mother climb the tree, high high high, to rescue, fetch, the twin, Kate's twin. There even before Kate was born on the earth. The twin who was Kate herself.

For are not all twins magic-born, the two-in-one, the never divided ones?

Like the twin trunks of a tree that grow high together. The ones like us, of the wood, of the ever life.

The twin was stuck. Up the tree. Too terrified to go up. Too frightened to look down. Too panicked to fall - but perhaps, perhaps …

The mother to the rescue, great climber she, even with her heavy heavy-ening weighty womb before her, in her way, the way of the close clutched trunk of the high growing tree. She climbed, she climbed, no thought for self, clambering fast-climbing up. To the rescue, mother-like.

So Kate, or was it her twin, or was it Kate who was rescued then? Kate of the wood, the trees? Her destiny? That she was born with. And self-shaped too.

The mother guided, helped, no fear by her of fall. One foot reach down, and one and one and one and one, the mother helping, knowing, love-no-fall.

And now feet at foot of the tree, on the ground, and then no more, they were there.

In the mother's womb now there was twinn-ed Kate-The-Seeing-Seen, The-Thinking-One, The-Seen-By-Us, by us the wood-growing trees. Our heroine.

We saw it all, and see. For we are the ones that know the hidden tracks in the woods, yes we the living ones who see her thoughts, the hidden unknowing thoughts of Kate-The-Seeing-Seen, The-Thinking-One, The-Seen-By-Us, by us the trees.

Of no *dead* elements are we, like earth or water are, or air or fire, but living, growing, thinking, feeling. Musicking in the resonancing of sweet wood. Not dead. Here, living the life of trees, to give life to humankind.

So

- as the wood grows in the life of the trees
- as flowers grow in spring to defeat the deadness of winter time
- as the sea's great flow follows the ebb and the moon wanes to wax once more
- as the sun sets over the purple dark of the sea to rise again

Even so, we the trees flourish in the woods to refresh the world each day, each year, each era of the great earth's way through the heavens. And recreate again, each day.

The school

Kate felt it, knew. She had to leave her home, her beautiful place. And go to school.

"Not 'school' ", said her mother, "it is a 'place of learning', Kate".

"Well, whatever. I know I have to. And those teachers - cruel. Ptero-ones. Or, or, maybe that was a different life and tale, can I escape?"

Well, go Kate must. She did. She left the heather, the sea, the blueness of the Donegal hills, for -

Chemistry! Sitting in a row to be talked at, lectured - unbearable. Being *told* about wood, not *feeling* it. Or the wind that sings to give us life.

We whispered in her heart, all quiet, we the trees.

"Kate, Kate, oh Kate. Listen to us and stay not here. Look look how the heavens call you, feel the full moon, the grasses too. Oh oh and we, the trees, we are here. See the blackthorn blossom and sway for you, the hazel bring sweet nuts for you, green and soft, the oaks show you the way to the stars".

"But I know I must learn", said Kate, "how else but in school - just does it *have* to be in rigid righteous reckoning rightening wrecking *rows*?"

She listened hard. The teachers told her clear, they, the teachers of that school, of the need-to-know stuff.

Like:

"Aside from water, wood has three main components. Cellulose, a crystalline polymer derived from glucose, constitutes about 41–43%. Next in abundance is hemicellulose, which is around 20% in deciduous trees but near 30% in conifers. It is mainly five-carbon sugars that are linked in an irregular manner, in contrast to the cellulose. Lignin is the third component at around 27% in coniferous wood vs. 23% in deciduous trees. Lignin confers the hydrophobic properties reflecting the fact that it is based on aromatic rings. These three components are interwoven, and direct covalent linkages exist between the lignin and the hemicellulose. A major focus of the paper industry is the separation of the lignin from the cellulose, from which paper is made , and - ".

"Well maybe true, but oh this is horrible, boring and maybe wrong for all I know. Aeons ago, and might have changed by now. Oh I *hate* 'school', hate it, *why* did they say I had to go to learn here, away from my beautiful Donegal sea-girt home?".

We whispered to her, there in her heart.

"Oh Kate dear child, do you not know that learning comes only from *yourself*. Not from teaching-ness. From what you see, you touch, you feel, *yourself*. From the scents and sights and musicked resonances of the great world, sounds of the spheres as they circle circle circle through the skies. Then circle again. Go out Kate, Kate-of-the-Seeing-Seen, The-Thinking-One, The-Seen-By-Us, by us the wood-growing trees, go forth and make it yours".

And so, she did.

In a magical world

We had done our best to prepare her there where she grew from out her mother's womb into the air of the trees. Growing into sense.

"So now", we'd said, "now it is time for you to learn, to *really* learn, sweet Kate, the innocent as yet, child of the soil".

"Where will that be?", she asked. Afraid. And trembling, "Where and with whom?".

We'd smiled.

"Not with dragons this time for sure or birds or dinosaurs but wandering free in a gentle wood, seeing the clouds, the sky, hearing the wood-sweetened music of the stars".

Oh Kate! She was not sure.

"For listen dear child, you must learn of the true way of learning, you must learn for yourself, from yourself, from the living ones around you here. Not from writ-books or reading, No. Did not your wisest mother say no reading, no eyes-down, mind-down, stultifying books as yet. No, first you must come into your realm

and see the secret magicking of nature, the world, that is around you. The sea. The mountains. Most of all, oh Kate, the woods. Look, look around, oh Kate, around at the living feeling things of the world".

She listened, she heard our music. She walked quiet in the woods, and saw:

- Hazel and green growing birch

- The curling furling fern, violets and primrose flowers, the nettle plants stinging but sweet to eat for those who dare, wild strawb'ries too, and climbing clinging rampant biting bramble to-bear-sweet fruit.

"Walk on the soil beneath your feet, oh Kate", we said, "among the plants, beneath the trees, and learn of them",

And so she did.

The great world of learning

So Kate tiptoed quiet in the gentle faerie wood, at home again. For there, at home, is the place for learning, not in rigid routine rowlocked chemical rows.

Content she was and filled with wonder-wondering, wonders of the primroses, sorrel of the woods with bitter salad leaves, white flowers, faerie harebells too with blue stolen from the sky.

Thorns b'low her sandal-less bared feet, she loved them all, and furling rolling curling ferns and shoots, waiting to become - who knows? - perhaps a tree.

And the resonancing 'ntrancing sound the woodwind made through the trees.

She heard and felt them all, they were hers, were *her*. She loved them all, did Kate-The-Seeing-Seen, The-Thinking-One, The-Seen-By-Us, by us the wood-growing trees.

PART II FLIGHT

She couldn't

Then next, a tree. A beautiful tree, high to the sky.

So why not climb? Her mother's craft, so surely hers.

"Yes climb Kate, climb, climb up", we said, "You have been there before, in your mother's womb, your destiny. You need not be afraid. Climb, climb, climb up. Look at the oak tree there, is it not aged and beautiful?"

She did not go.

"Climb, climb, climb up", we said again, "it is high and beautiful, you will see the beauty of the wood, the trees, the primrose flowers".

She did not move.

"Climb Kate, climb, climb, climb up, So will you find him at the top".

Him?

She was not willing, did not go. Climbing was her fear, her special fear. Knew she would fall.

But climb she must, for she was Kate, the pearl in the darkening deep wood, she Kate-The-Seeing-Seen, The-Thinking-One, The-Seen-By-Us, by us the trees.

"You must, you *must* climb up to there. To where he is waiting, Kate, for you, your destiny, there at the edge of the sky, the living stars, the way to heaven".

She climbed a little way.

Then panting, gasping, breathing fast, she turned, looked down.

"I am too young, too fearful still", she said, "too young for here, to climb, for grown-up love, for dizzying. I cannot do it, cannot cannot climb".

She turned, looked down.

"I will fall", she said.

And yes, we heard her feet scrabble on the oak's great trunk, hands fail to grasp the branches, twigs breaking clutched in vain, and falling, falling, falling down.

Sound of her steps as she ran ran ran, away from the thought of climb, of him. Afraid.

We heard the footsteps, listening. Surely we would find her leaning her head against a tree, a tree of ours, and bring her back.

No.

She was gone.

The great secrets

She was learning so much even as she failed and fell.

The sky, the stars, the hidden magics of the earth, the galaxies, the cosmic everything, the universes all.

The herbs of health, of heaven, of deep sea mysteries.

The puzzles, secrets, of her life.

But

She was safe now. Wasn't she? She had fled and got away.

Thud thud thud with her fast flying fleeing flighting feet. Was saved.

But -

She heard a call to her. Him. Him? *Coming after her*, And nearen-ing nearen-ing NEARENING still …

"Come here", she heard, "Come here to me". Calls confid-ent. Was - *him.* The him she feared, she'd flighted-fled.

She cowered, hid, beneath the leaves.

"Come here", he called her, gently now, "I will not hurt".

That made it worse.

And worse again. Fearsome-ing her.

She hid 'neath a holly tree's sharpened shining sheltering leaves (she hoped). Hid in the shading dark of early morning time, he would not see her there.

Ah but the sun was come, the sun's bright rays, discovering her. With thundering feet he came, came after as she fled.

She felt she feared she *heard* his footsteps coming after.

Where could she go?

She remembered the story her mother told her when she was young. Of the nymph that fled Sun-God Apollo's lust.

"A laurel!", she'd said, "Do not just run, *become* a tree, a fragrant laurel tree, no ravishing possible then. A tree is forever, in its way".

She tried. But - she could not help - her branches quivered and trembled and turned pale. And reached out to him. Her arms to him.

Oh no!

What could she do but flee again.

Away away away.

Her footsteps died in the distant woods. No sound by now. She was gone.

And he?

Angry?

No good at all but just himself, a-wanting her. To love her true, for her to be truly his, content, for evermore.

He stood alone. Again.

Bereft.

Alas for him.

What now …

What now for Kate? When he was left bereft.

Bereft - she did not know. Or did she, perhaps?
Somehow? In her deepen self, in her dest-iny?

Where must she go, what do?

She looked in the heart of the primrose flower as her
mother had said,

 It did not speak,

She looked to the moss at her feet.

 It did not tell her.

She looked at the clouds above.

 They were silent too.

She looked to *us*, the trees.

We spoke, together, all.

"Africa, Kate, go there. Listen to the voice of a wise
tale there".

She went.

She listened. And - more - she heard.

PART III DISCOVERY

Africa, a story and …

And what did she hear?

"Listen", we said, "that you may know".

We clustered round to hear.

A story-teller stood up there to speak. Karanke Dema named, the village drummer-smith. He spoke by parables, deep to Kate's heart. And ours, the trees'. Yours too mayhap.

"Come all ye, come" he cried. Listen to the tale, the tale called forth for you, a tale of love. And of death too [2].

He began.

"Once upon a time a village chief planted leaves to make sauce for his meals — spinach.

Well, the wet season came, the hungry time. There was a man there called Sara, living away from the village, in the countryside. He said to his wife, 'I am going to go and beg the chief for some spinach, just one small bunch, we are so hungry'.

But when he asked, the chief said, 'If you take any of it, I will kill you, *no one* must pick it. Forbidden'.

Sara said, 'All right'. But in the night he came secretly and took some. For his wife and family.

What happened next? Ha, when the chief came into his garden next morning, he *saw*.

He sent a servant to Sara 'If you are the one who took it you must confess. *Now!*'

Sara said, 'Yes, it was me. I went and begged for some yesterday, for my family, but the chief refused. So I took it'.

When he heard that the chief set out from his village. He took his sword. He sat on his horse. He lashed his horse *gbang*! He went, galloping, *raaa*, right to the farm.

When he got there he said, 'You sitting there, I have come for *you*. You went and took the spinach. I have come for you'.

When Sara tried to speak, the chief drew his sword and struck him. Ah! he killed him.

The young wife was left alone there, pregnant.

She said, 'I won't stay here, here where my husband was killed because of bunch of spinach. If I stay on here we too will be killed'.

She off and lived far away.

When she bore her child, she gave her the name of Kati".

"Kati", we said, we the trees. It is a magical name".

"Yes, like 'Kate' ", murmured the cherry and swung her fragrant beautiful flowers, "Kate-come-again in the great cycle of the ages under the constellations of the stars".

"Hush", said the beech, reprovingly, "listen to the story. What happened next?"

That Kati— when she began to cry her mother would croon to her, 'Hush, oh, child, hush. Your father was killed for a bunch of spinach' ".

That was good, was right for her to sing that, we joined in, the young child must know as she grows up.

"Perhaps she - ?"

"Yes", said the story-teller, "you will hear. And that is right, that you help my telling with your chorussing ".

So we sang again, helping the story on. And helping Kati, *our* Kati Kate, as she journeyed through her cycled journey of story".

"Of *life*", said the cherry.

"Of the soul", said the holly and the apple tree together, and smiled at each other.

"Always, always, always the mother sang these words to her child - as she suckled her, till she could sit, till she could walk, till she was weaned— she would keep singing that and Kati would listen.

If Kati began to cry the mother sang, 'Hush, oh, child, hush. Your father was killed for a bunch of spinach' ".

That was good, was right, we joined in, the young child must know as she grows up. Perhaps she - ?

"Yes", said the story-teller again , "you will hear. And that is right, that you help my telling with your chorus singing".

"Just listen", said the beech.

We did. We thought it was exciting. Sad too.

When Kati grew and got sense and her breasts filled— *berede*! everyone tried to woo her. She refused them all.

Then she asked her mother. 'Mother, what happened to my father?'

Her mother said, 'Your father was killed for a bunch of spinach. By a chief'.

'What was the name of that chief?'

'Ha! I don't want to think about him. And where I came from is far far away, a long way from here'.

'Well, point out the road to where you came from'.

The mother did.

It was the girl that asked. Her breasts were well filled oh! Beautiful oh!

Kati stood up. She put on beads, as far as her navel. She bought a hanging loin cloth, she put it on; she chose a beautiful head tie, she put on a head band of beads, and hung beads on her neck, and covered her wrists with bracelets. She tied her clothes in a bundle.

'I must find the one who killed my father for a bunch of spinach'.

She set out, she began to go.

She came to one village. Everyone stood up to look at such a lovely girl. As she stood there they said, 'What a fine girl, she is a perfect woman on earth, beyond all others'. They stood up and welcomed her.

Kati entered the village square and stood there. She was greeted with

'Any trouble?'

'No, no trouble. I am travelling inquiring, looking for the chief who killed a man for a bunch of spinach. When I find him, he is the one who will marry me'.

Ha! all the men there wanted her in marriage. But they said,

'No, that chief is not here'.

Kati went on. She went for very far. She came to another village. They welcomed her. She came and stood outside in the compound. They all wanted to marry her there. Everyone was standing there, getting ready to offer a marriage gift for her.

When she was asked, 'Any trouble?' she answered, 'No, no trouble. I am here to make a free marriage with someone'.

Ha! they all got ready. 'I love you!', 'I love you!'

She had marriage gifts brought out for her. The kolanuts given for her came to one hundred. The money given for her came to £20! They were gifts for marriage. Everyone was bringing out gifts.

Then she said, 'For me— all that you have given, I have looked at it all. But the one to marry me is the one who killed a man for a bunch of spinach'.

They said, 'Ah, but he is not here, he is not here '.

She went on. She went through six villages. She asked for him. But he was not in any of them.

At last she came to the village where that chief was, he was called Saio.

She was welcomed. She entered. She came right in. She came and stood outside the chief's house. The chief's assembly drum was beaten—*gbing, gbing gbing, gbing, gbing gbing.*

The people gathered. They came and looked at her. If you saw that girl— ohh, there was no girl to match her in the whole country.

When she had had the gifts given to her -—well, you know what power is like! they all thought that she had come to live with the chief, to stay in his house with peace in her heart. They brought out kolanuts as a first gift for her - two hundred. The money was as much as £60— just a first gift! She took it.

'I have seen the money', she said,'it pleases me. But the one who is to marry me is the man who killed someone for a bunch of spinach'.

Saio stood up from where he was sitting. His heart throbbed to marry her.

'The woman I love has come, the woman I love has come', he cried. 'She, it is she who will look after me when I am old'.

He stood up. He came outside to her.

'Here I am!'

He tapped himself proudly. 'Here I am. I am the one who killed a man for a bunch of spinach. It was growing in my garden. That was what he came and cut. That is why I killed him. When he came and begged for it - 'My wife is hungry' - I refused. That night he came and stole it, one bunch, one bunch. That angered me, that is why I killed him. It was I, I Saio'.

The girl said, 'All right'— the girl called Kati— 'now I have found my mate. For he is the one I was seeking. It is you who will marry me. I have come to the marriage'.

She smiled - inside she was full of anger.

Then the chief stood up. It was as you usually do— if a wife comes for you, a new wife, you make a sacrifice for her. He gathered all his headmen and announced the news to them.

The girl— the one called Kati— said 'It is good. I came for a marriage; now I have found my husband. My mother gave birth to me over there; they began to woo me there in marriage, they killed a cow for me. But I did not agree. I said I would wait till I heard of a man who had killed someone for a bunch of spinach. Now I have found him, my husband. I am glad. With Saio here I will stay'.

He was a great, great chief. Powerful. Ha!

You know how it is with a new wife. The chief said to his other wife 'You will not sleep here tonight. Get out! My new wife, Kati, will sleep here tonight'.

They spread the bed for her. A new wife, sitting there in all her blackness — well, that is what we call a fine thing! The time came …"

"Ohh!", we all said, Kate too, "Go on, go on, go on".

The story-teller looked at Kate and hesitated.

"I know why", said the holly. "It is too blood- , ah blood-filled".

Kate shuddered. "But I need to know", she said.

Silence.

The cherry tree dared to speak. "I know the story. Listen. The chief took the girl to his hut for the night, all sweet and delicate and innocent and delicious as she seemed to be. He told her again, boasting, how he had once killed a man for a small bunch of spinach. And fell asleep".

"And then?", we rushed to ask, all together.

"Then? The girl found his sword. She took it.

"She stabbed him, she killed him. Dead.

"In the morning the chief's senior wife came and looked in the hut. All she saw was flies *buzzing buzz buzz buzz* over the chief's dead body. The gifts all gone. No girl".

"Ohhh", we all shuddered, "horrible".

The cherry tree went on "The chief's son, his handsome handsomest eldest son, the chief's

beloved heir, stood up in fury. He leapt on his horse, and galloped off, *raaaa.* 'I will avenge my father', he cried, 'I will find her, I will *kill* her' ".

"Yes", said the story-teller, "you are right, shall I go on?"

We looked at each other, not sure. We do not like bad endings. More blood. But maybe something more as well? We nodded.

"*Yes*", said Kate.

The story-teller spoke again, uttering the tale in a loud voice, resounding through all the resonant deepest wood. We listened.

"The boy was galloping, fast fast fast, *raaaa.* Furious. On the track of the girl, of Kati.

As the sun was coming to the mid point exactly, he came up to her— 'Hey! you there, you there, don't move from where you are, it is you I am pursuing. Stand!'

The sword had been given him, he'd been told 'If you find her, kill her, to avenge what she has done to our father, our great great powerful chief'.

What did Kati do?"

"We don't know", we said, we the trees, "what *could* she do! We suppose he killed her and took back his sword to the village covered in her blood".

"No, just wait Before he could reach her, she took off all her clothes. She just stood there in her blackness, her beautiful blackness.

The boy came up to her on his horse - *thadang thadang* - he turned his eyes towards her, secretly looking at her.

Ha! He got off his horse. His heart was pleased with the woman. 'Ah, you, you - you are the one I am pursuing. You killed my father. You killed our chief'.

Kati said, 'Yes, it was me. I killed him. Is that why you have come?'

'Yes.'

'Mm, is that really why you have come?'

'Yes'.

'To kill me?'

'Yes'.

'Let me ask you a question. Which do you want— to kill me, or to marry me?'

The boy— his heart went out to her, to marry her. The reason he had set out there was forgotten.

He said, 'Ah, I want to marry you— even if it means I never go back. If they want, they can bury my father without me. I am not returning— let us go, you and I, to your home. Or if they say that I have to go back with you, we will go on my horse together and I will say that you shall *not* be killed. I will marry you!'

Kati said, 'All right. I agree. But before you marry me, first pick me a leaf from the tree there. I want to drink, I am thirsty'.

The boy got down from his horse, and made it stand waiting for him. He hung the whip by its neck. He stuck the sword in the ground.

'Am I to climb up for it now?'

'Yes', she said, 'but for climbing it is best to take off your gown and your trousers. Put them down with your cap and go and pick the leaf for me'.

The tree was very tall. Ah, you know".

We all nodded. We did. We held our breaths. A tree! Surely the climax was coming.

"So the boy began to climb, heart now fully turned towards the girl as she stood there in her blackness with her beads round her loins. Oh, she pleased him! (*he* was quite attractive too, you know!).

He put his arms round the tree, he climbed up. He came to one leaf.

'Is this the one I am to pick?'

'No, not that one'.

He climbed higher, he came to another.

'Is this the one?'

'No, not that one.' He climbed further, he pointed to another one.

'Is this the one?'

'No, not that one; the one on the very top'.

He climbed up to the very very top.

He looked down at her standing below, and he knew that he loved her.

But she said 'Now you are right up there, now I am going,. You just stay there, *I* don't care'. I am called Kati, I am not yours, goodbye!'.

'I love you', he said, 'whatever you do, whatever you have done, for ever', he said".

We understood that. Love.

We saw it.

For

 - as an all-consuming fire burns through huge forests on a mountain top, and men far off can see its light

So was his love for her, blazing with a fierce strong fire.

 - as flocks of birds—geese, cranes, and long-necked swans—fly here and there by the riverside, proud of their strong wings, and call as they settle, the meadow resounding with the noise, [3]

So was the boy's love, waiting there for her, for her alone. Come come'.

"She didn't look up at him, just got on the horse. She took the things he had taken off. She took the horse. She took the whip. She took the sword. She lashed the horse, *gbang*, to go to her home, holding the sword, holding the whip, with the boy's things hung over her shoulder.

She left him there. On the tree. High high high. Longing for her. Waiting.

She galloped off.

… and a storm

"No!" came a scream. Kate,

The story-teller stopped.

He came close to Kate, too close. His eyes looked into her, deep deep, like down-ed oak tree roots.

We listened with our ears. And heard him speak to her.

He spoke.

"You must pursue your destiny oh Kati-twinned-with-Kate", he said, "your duty, fate, your calling, talents, all. Up till the end, ev'n to the end of time. Is he not waiting there, there in the tree? For you?"

"But … "

"Yes it is hard. You must harden fast, hard-fast, your knees, your mind, your heart. Many will say 'Leave it, no good, leave it for others to do'. But *you* …"

We listened for her word, we the living ones, the trees, the wood.

At last, at last she spoke and said the words:

" I understand", she said.

"That I must seek … ah but seek what"

"Seek *him*".

But then her calmness broke, ah ah disintegrated scattered splintered, a thousand broken pieces flying in a torrent.

She screamed again, and shrieked. It was too much.

What did it mean, that story told to her? Who was it that was waiting there? For *her*? And he'd said he loved her. Abandoning him atop that tall tall tree?

"Yes', said the story teller, "that girl, that Kati, *abandoned* him, when he was giving all up for her, for love of her".

"Did - did he climb down from the tree? ever?", asked Kate, small trembling voice.

The story-teller looked at her, did not reply.

"Finish the story, finish the story", we cried. Urgent. "How did it end?"

"I do not know", he said.

Then Kate's mind saw him there, abandoned on the treetop, no way down. She struggled struggled with that knowing.

- as the winds of autumn whirl thistledown round and round upon a road

- as dry chaff is tossed about by a whirlwind

- as winds play battledore and shuttlecock, and all at once

- as a terrible great wave rears up and up and up to break over a struggling ship [4]

So the storm of her knowing broke over her, in earthquake, volcane, torrent, hurricane.

"I must find where he is waiting", she cried out, "for, oh oh oh, I love him, now I see, I love, love, love, I did not know. I will seek him till I die. And after. In all the woods, the boughs, the treetops of heaven and earth, until I find".

In her agony despair and revelati-on, words not enough, just song of plead imploring begging longing. Of agony, remorse, regret, repenit-ence.

"I long for you as one
By hurricane oppressed
Lost in the storm-crossed treetops
by storm and wind distress't
goes without handhold, love-less

no friend no help no light
O look from the tree-top, climber
look past the skyline's sight,
look for the heaven's shelter
My love to final test" [5]

And more -

For

- as cranes screech overhead, when winter's harsh storms have come, screaming as they move over the flowing ocean, bearing death and destruction to all, launching a savage attack on them at dawn.

- as the South Wind spreads mist around the mountain peak, that shepherds hate, but thieves prefer to night, and dust clouds rise from underfoot

So was she overwhelmed, lost, agonised, despair of love she hadn't known.

And oh, for him.

It was enough. She sank sobbing to the ground and our branches enfolded her there.

"Yes", we murmured soft. Gentle as the wind soughed quiet through the leaves. 'We must endure, we all, to the story's end".

PART IV AND NEXT

The sun

She look-ed up, up to the glaring piercing sunnes rays, a-burning, scorching, blinding her, afraid-ening her as well.

She shielded her eyes. A bit. One hand.

He was atop that small thorn bush. There, just next the top. Right up, over the place she lay, lay a-wanting him. Would die for him.

She saw him struggle to hold on.

No leaves to shield him from the sun. Was thornbush bare. No leaves, no shade. No smooth handhold.

No hat.

She saw him shrivel, scorching, in the heat.

She saw the sun there, stroking him. Not gently, no. *Sunstroke*-ing him,

Her too, but she, she had a hat. She was all right.

He would fall, she knew. In weakness, hotness. Swaying. Faint. Sun-stroked. No shade, no covering.

What could she do?

Her hat? Her hat to him?

No no, sun too too hot, she'd always feared it, knew it could bring her death, would shrivel her dry, hot dusten her, oh no, oh dearthen'd, dying, scorch-ed, flameed, waterless.

Sun stroke.

She could not.

But but - she *must*. Hard was it in the heat, the agonising rays, but yes, she must, she could, she *would.*

Took off her hat, threw up to him.

It missed.

She tried again, again, again. Hotter and hotter still. And oh how it hurt. The missing. And the sun on her head, within her, boring and awling into her, right through, spiralling corkscrewing down and down again int' her inner inwards gut, and killing her.

Hat on the ground. Last feeble throw.

It landed, full on his head.

She shut her eyes, was done.

Saved

So he was saved.

Not her. But who cared about that? Just lie there, scorch and fry and burn, for *he* was safe.

And gone. Leapt to another tree. And gone. In health again (the hat).

Yes - gone.

Hot hot

She would die. She knew. And that was right. Maybe he'd find her after the years'd gone past, another universe, another life. When time was right.

Sun's shrivelling rays upon her. Hot hot hot,

Shadows

The sun moved in the sky. Some shadows fell. But few. And not on her.

We moved our branches softly, we the trees. So now, they shaded her.

Shade, coolth. Oh Kate!

But now she must go on. On in the sun?

We whispered together softly, we the trees, we plotted, planned.

And lo - garland of leaves now there, our gift to her, look look, for Kate's dear head, against the piercing sun, its deadly rays.

"Go on go on sweet maid. Many trials to come, it's true, you may not pass the tests, but, yes, you *must* now try, you may at last prevail. In search for him".

She rose up, and she went. With garland on.

PART V THE TESTS

Of informati-on

Kate halted. Sudden.

"To pass on in your quest oh Kate", she heard a voice from - was it above? below? herself? Or ev-ery where? "you must show forth your knowledge first. No passing else".

"Oh", said Kate feebly. Nervous she was (no wonder, that).

"Tell us then Kate - first, what is wood?"

Aha, she knew, The pterobirds in the treetops before their flighting south had tolden her one time in the darkness of the night.

She rattled it off (did she understand it? who can tell?). What she remembered from that, er, horrible meteored sitting-in-rows ptero-dinosauring-time.

"The chemical composition of wood is approximately 50% carbon, 42% oxygen, 6% hydrogen, 1% nitrogen, and 1% other elements (mainly calcium,

potassium, sodium, magnesium, iron, and manganese) by weight. Wood also contains sulfur, chlorine, silicon, phosphorus, and other elements in small quantity ".

"Er yes", we said,"Chemistry okay, but what about the *uses* of wood? that great great living thing that - ?"

"Yes yes I know", huh, interrupting us she was! "wood is used for …"

"Yes?"

"Boats. Houses. Wagons. Flooring. Fuel. Roofs. Scaffolds. Crosses. Ladders. Oh oh, *everywhere*".

"Go on go on".

"Sports things, like cricket bats and ones for tennis, baseball, hockey - and, oh, all that".

Kate not a sportsman, er sports *person* she!

"And? And? Think timber and stuff?"

"Oh, *timber*. Yes, that good too, easily available building stuff since humans started making shelters".

She gabbled it out. "It is used in the construction of buildings, bridges, trackways, poles for power lines, masts for boats, pit props, railway sleepers, fencing,

hurdles, shuttering, pipes, scaffolding and pallets. In houses it's used in joinery, joists, roof trusses, roofing shingles, thatching, staircases, doors, window frames, floor boards, parquet flooring, panelling and cladding".

"Yes, enough …" (as if we didn't know)

"No listen. Wood is used to make carts, farm implements, boats, dugout canoes, in shipbuilding too. Furniture, boxes, ladders, musical instruments, weapons, matches, toys, pencils, rollers, cogs, screws, barrels, coffins, skittles, veneers, artificial limbs, and oars. It's pulped for paper, cathedrals too … " 6

We listened well, heads bowed in thoughtful contemplati-on, reverent, dignified, the hushed breeze making sweet melody as it whispered through our leaves.

The cheeky ash sapl' wasn't satisfied.

"Nuff of the mundane man-done human stuff", he upped an' said, he did. "Summin' uplifting's wot we need".

"Cathedrals not uplifting?", wondered the holly to herself.

"Dunno", said Kate.

The beech leaned down with its lofty head.

"Seeds and sucklings", he said, "The words of. Those things are good oh Kate - but what of the things that are our own, where we live in wisdom, using it, that give us truth and energie, *our* life?"

"Ah, er, you mean?"

"Think now of us", said the beech, "us living things. Not wrought by Man" ("or woman either" muttered Kate) or made by human hand like boats or wrecks or rails or roofs, but of ourselves, *our* destiny".

"Like these?", Kate lightly touched the oaktree's mighty trunk, the one she stood against.

"Yes trunks and leaves and ..."

"I know, I know. And where to start, I've not forgot".

"Then", gently laughing,"tell us then".

She did [7].

To start again

"Roots, roots are magical", she said, "roots of a tree that anchor to the ground and gather water and nutrients to transfer to all the tree. They are for reproduction, for defence, survival, storing energy and much much else. The embryonic root is the first part of a seedling to emerge from the seed as it germinates, then into a taproot going straight down downwards. Within a few weeks lateral roots branch out the side of this, grow horizontally through the upper layers of soil. Then the taproot withers, the wide-spreading laterals remain. Near the tip of the finer roots are single cell root hairs, in contact with the particles of soil, absorb water and nutrients like potassi-um. Remarkable.

"In the soil, roots meet the fungi hyphae, mutual relationship with the roots, some with just one tree species, some with many kinds. The tree gets phosphorus and other minerals from the fungus, the fungus gets the carbohydrate products of photosynthesis from the tree. Thus - is it not awesome? - it can link different trees to a network in

transferring nutrients and signals from each to each. The fungus promotes the roots' growth and protects the trees against predators and pathogens and damage from pollution. And fossils show that roots have been associated with fungi since four hundred million years ago, when the first vascular plants colonised dry land".

"We knew all that", we said, "no need to tell us. Still, it is good *you* know it too".

"Don't interrupt", Kate crossly said, in lecturing mode.

"All right", we said, and smiled. "Go on. It's good".

"Some trees are interconnected through their root system, a colony. The interconnections are made by the inosculation process, a kind of natural grafting or welding of vegetal tissues. The roots are generally an underground part of the tree, but some tree species have evolved roots that are aerial. These aerial riots help the mechanical stability of the tree, and to obtain oxygen from air. Many large trees have buttress roots, flaring out from the lower trunk, they brace the tree like angle brackets and provide stability, reducing sway in high winds. They are prevalent in tropical

rainforests where the soil is poor and the roots are close to the surface.

"Some trees have root extensions popping out of the soil for oxygen, when it is not available in the soil because of excess water, like black mangroves and pond cypresses".

"The trunk?"

"Shut up, am just about to say".

We smiled again. We knew.

"The main purpose of the trunk is to raise the leaves above the ground, so the tree overtops all other plants and outcompetes them for the light. It transports water and nutrients from the roots to the aerial parts of the tree, and distributes the food produced by the leaves to all the other parts, including the roots. It provides a thick, waterproof covering to the living inner tissue. It protects the trunk against the elements, disease, animal attack and fire. As the tree's girth expands, newer layers of bark are larger in circumference, and the older layers develop fissures in many species. The bark is a protective barrier, but it is itself attacked by boring insects such as beetles that lay their eggs in

crevices and the larvae chew their way through the cellulose tissues leaving a gallery of tunnels. This may allow fungal spores to gain admittance and attack the tree, like in the Dutch elm disease, blocking off the tissue carrying sap upwards and the branch above, and eventually the whole tree, is deprived of nourishment and dies - in millions".

"Alas, alas".

More lecture mode (no comfort there).

"Trees grow not continuously through all the year but in spurts, then periods of rest when it's too cold or dry. In readiness, trees form buds to protect the zone of active growth with twig form scales - thick, small and closely wrapped and enclose the growing point in a waterproof sheath. Inside this bud is a rudimentary stalk and neatly folded miniature leaves, ready to expand in the coming growing season, astounding is it not! When warmer weather comes and longer days, growth starts again. The expanding shoot pushes its way, shedding its scales as it goes. These leave behind scars on the surface of the twig. The whole year's growth may take place in just a few weeks. The new stem is unlignified at first and may be green and

downy. In time the growth of a tree slows down and stops, it gets no taller".

"It's true", we sighed. "And leaves?"

"Aha", said Kate, uplifted now, "the leaves! Specialised for photosynthesis they are, arranged on the tree to maximise exposure to light without shading each other. They are an important investment by the tree. Trees have evolved leaves in many shapes and sizes, in response to environmental pressures like climate and predation. They can be broad or needle-like, simple or compound, lobed or entire, smooth or hairy, delicate or tough, deciduous or evergreen. The needles of coniferous trees are compact but are structurally similar to those of broad-leaved trees. They are adapted for life in environments where resources are low or water is scarce. Frozen ground may limit water availability and conifers are often found in colder places at higher altitudes and higher latitudes than broad leaved trees. In conifers such as fir trees, the branches hang down at an angle to the trunk, enabling them to shed snow. In contrast, broad leaved trees in temperate regions deal with winter weather by shedding their leaves.

"When days get short and the temperature starts to decrease, the leaves no longer make new chlorophyll and the red and yellow pigments already present in the blades become apparent. Synthesis in the leaf of a plant hormone called auxin also ceases. This causes the cells at the junction of the petiole and the twig to weaken until the joint breaks and the leaf floats to the ground. In tropical and subtropical regions, many trees keep their leaves all year round. Individual leaves may fall intermittently and be replaced by new growth but most leaves remain intact for some time. Other tropical species and those in arid regions may shed all their leaves annually, such as at the start of the dry season. Many deciduous trees flower before the new leaves emerge. Trees are pollinated by wind or insects. Their seed dispersal is by wind, or animals, like through edible fruits, or by ejected seeds or falling by gravity.

"To grow to an adult tree needs light. And that takes various forms …"

"Yes, yes, we know, go on".

"Oh well, all right. What should I - ?"

"Our history", we said. "Way back", we added, proud.

"Er, er. Well yes, I think I know. In dynosauric times".

" Before", even prouder still, "before, before. Do you not remember it?"

For she was old, Kate-and-her- twinn-ed shadow self, mythic and archetypal, older than the moon, the hills, the wine-dark garrulous sea.

"Er yes", she said, then gabbled quick lest interrupti-on again.

"The earliest trees were tree ferns, horsetails and lycophytes, which grew in forests in the Carboniferous period, reproduced by spores not seeds, some, unchanged still from 300 million years ago, and more.

"During the Mesozoic, many million years ago, conifers learned to live in terrestrial habitats. Next, the tree forms of flowering plants evolved, and forests covered the globe. The climate cooled 1.5 million

years ago and the first of four ice ages came, the forests retreated as the ice advanced. In the interglacials, trees recolonised the land once covered by the ice, then were driven back again in the next ice age".

"Good, Kate, oh good. And now, so here we are. We, trees of the precious earth. Give thanks".

And more

"Yes, you've done well", we said, congratulating her. "But is there - ?"

"More? Oh yes", she said. "There's better - like artistic things, like carving, sculptures, makings by human hearts and hands".

Hush, would she … that ever-enchanten-ment of wood … The sound from the trees' heart, the resonating resonancing notes and melod-ies ….

'Oh yes, the best". Kate smiled. "For musicked instruments. Stradv' cellos, others too, violas, vio-lins, and keyboards too. The magic things".

The trees themselves

So she spoke well.

But - we looked at each other. Had she not, perhaps …? Forgot?

She took a breath. We waited, patient (some less so of course) .

"And best of all", we drew a breath, "the *living* things of wood".

Ah!

"*The trees, the trees of now*".

"Yes, what of them? Their science, uses, evoluti-on?"

"Ah yes", she said, "I've taught myself 'bout all of that".

"And?"

"But I've said all that … "

"So say again"

"Well, trees you know …"

We did, we do.

"Trees are not a monophyletic taxonomic group but a variety of species, plants, so clever, evolved a trunk

and branches to tower above all other plants to compete for sunlight. Trees tend to be long-lived, some several thousand years of age. Trees have existed her on earth for 300 million years or more (did I not tell you back just then?). And - there are around three trillion mature trees in the world.

"Trees typically have branches kept clear of the ground by the trunk. This trunk has woody tissue for strength, and vascular tissue to carry materials from one part of the tree to another. For most trees it is surrounded and protected by a layer of bark. Below the ground, the roots (remember them?) branch out and spread; they anchor the tree and get moisture and nutrients from the soil. Above, the branches divide into smaller branches and shoots. The shoots bear leaves that capture energy from light, convert it into sugars by photosynthesis, food for the tree's growth, development.

"Trees mostly reproduce through seeds from flowers and fruit, but conifers have pollen cones and tree ferns spores instead.

"Trees can reduce erosion and moderate the climate, removing carbon dioxide from the atmosphere.

Miraculous, so why not cherish more? And plant? Trees and forests are a habitat for many species of animals and plants, tropical rain forests among the most biodiverse. They bring shade and shelter, timber for construction, fuel for cooking and heating, and fruit for food, and much much else? Alas forests are shrinking trees are cleared for agricultural land. For their longevity and usefulness, trees have always been revered, with sacred groves and a role the world's mythologies".

"Yes good, oh Kate", we said,"but what exactly *is* 'a tree'? The definiti-on? Not fussing, no, just humbly, wondering. 'Gnothi seauton' [8] the ancients always said".

"You are right to not-know, for there is no precise defining of a tree", said Kate.

"Well, try, oh Kate".

"Er, a tree is a plant with an elongated stem, or trunk, which supports the photosynthetic leaves or branches at some distance above the ground. Trees are also typically defined by height, with smaller plants from 0.5 to 10 m being called shrubs, so the minimum height of a tree is only loosely defined. Large

herbaceous plants such as papaya and bananas are trees in this broad sense.

"The narrower definition is that a tree has a woody trunk formed by secondary growth, meaning that the trunk thickens each year by growing outwards, in addition to the primary upwards growth from the growing tip. Under such a definition, herbaceous plants such as palms, bananas and papayas are not considered trees regardless of their height, or form or girth. Trees can also be defined by *use*; like, plants that yield lumber".

"Go on, go on".

She sighed (the foolish girl, who could be bored by hearing of *us*, the living trees, the deepest wood?).

"Trees are tall, long-lived:(well, mostly are), some are thousands years in age, among the oldest living organisms now on earth".

"Good. Now say more. For we are *us*, the greatest living ones".

"What about humans though?", said Kate, then looked at us and hurried on.

"Trees are either evergreen - green all the year - or deciduous, shedding their leaves as the growing season ends, then a dormant period without foliage. Most conifers are evergreens, but larches are deciduous, dropping their needles each autumn.The crown is the spreading top of a tree, the branches and leaves, while the uppermost layer in a forest, formed by the crowns of the trees, is known as the canopy".

Knowledge not-knowledge

Then came from above the voice again. Was it the
Great Lord of the Forest, The Mighty One, the Ruler-
of-all-the-Woods. We bowed our heads for that was
right, and hushed our whispering wind-shook voices,
quieting them.

"*That* is not knowledge", we heard the voice, "Just
info, curriculum and syllabus, just learning stuff".

"Then what?", said Kate. Nervous, now nervouser,
then nervousest, oh worse, before them all.

"What can it be?"

Wisdom", it said, "the wisdom-truth of musicked
poetry, sweet words and song".

"But I don't...", began Kate.

"We think you do " we whispered low to her. We knew.
Listen.

> "The woods are lovely,
> dark and deep.
> But I have promises to keep,
> and miles to go before I sleep" [9].

"Well that's true", said Kate, "Miles to go. Alas".

"*Poetic* miles", we told her, "that's different".

"Worser", she said, "and promises, that's worser still. And to him, whom I cannot find. Waiting for me up that tree, worsest of all. Why don't you help instead of playing with words!".

"But they can help. Well at least have a try", we urged her. Urgent, urgent-testing her.

One …

"Well …", began Kate.

"Without that wisdom lore you may not climb", we prompted her.

She heard the stern voice of the Great Lord of the Forest, The Mighty One, the Ruler-of-all-the-Woods, but hesitated still. She did. She hesi-tated sore.

" Well, I …", she began.

"We'll help" we whispered, low like the breeze in the topmost twigs,"he is too stern with you".

 "Well, I'll try". began Kate, "but I don't really know any …".

"Well yes you do", whispered the apple tree (he'd been around since the beginning, and knew a lot, of good, and of evil too) "Remember 'love the trees ..' ".

Kate did. She smiled, and spoke -

"Love the trees until their leaves fall off, then encourage them to try again next year".

"Good", he said, he, the Great Lord of the Forest,
The Mighty One, the Ruler-of-all-the-Woods, "but we
need a greater *longer* wisdom-one".

"But I don't know any longer ones".

"You do", we told her heart, " Think autumn, a
November night, and … ".

"Oh, ah, ah. Perhaps - "

 Her heart heard with a sweet voice and sang

Two

"Listen. . .
With faint dry sound,
Like steps of passing ghosts,
The leaves, frost-crisp'd, break from the trees
And fall" [10].

"You're doing well", we said. "What next?"

But Kate was stuck again. Not much of a safari walking woodland girl she was.

But listen, seeping down through her mind from - from somewhere, from some tree, somehow.

The birch quivered her silvered golden leaves, self consciously.

"Look at me", she seemed to whisper, quietly, "am I not … ".

We nodded in unison, in sound. Agreed.

"Um. Birches", muttered Kate.

Three

 "Ah, ah, I know". She lifted up her voice, and the voice rang with a sweet sound among the trees.

And

- as the wind whispers through the leaves

- as the rippled waves sound quiet upon the sand

- as the nightingale-notes ring in the woods

So she sang long and clear, not *her* words but those of a great bard of old who lov-ed, cherished us. And understood.

"When I see birches bend to left and right
Across the lines of straighter darker trees,
I like to think some boy's been swinging them.
But swinging doesn't bend them down to stay
As ice-storms do. Often you must have seen them
Loaded with ice a sunny winter morning
After a rain. They click upon themselves
As the breeze rises, and turn many-colored
As the stir cracks and crazes their enamel.
Soon the sun's warmth makes them shed crystal shells
Shattering and avalanching on the snow-crust—
Such heaps of broken glass to sweep away

You'd think the inner dome of heaven had fallen. ..

I'd like to go by climbing a birch tree,
And climb black branches up a snow-white trunk
Toward heaven, till the tree could bear no more,
But dipped its top and set me down again.
That would be good both going and coming back.
One could do worse than be a swinger of birches" [11].

Four

"Another now", came the Great Voice of the Lord of the Forest, The Mighty One, the Ruler-of-the-Woods.

"About wood, would that be all right?", asked Kate.

"Yes", we all cried, "of that precious material are we not made?"

"You speak true", spake the mighty voice, "sing on oh Kate".

"It's quite old", she said apologetically.

"Never mind". We held our breaths,

"She gave him a great bronze axe that suited his hands; it was sharpened on both sides …"

"Bronze", we interrupted, " that's not …"

"Just wait", she said and hurried on, regardless-ing of us.

"and had a beautiful olive-wood handle fitted firmly on to it. She also gave him a sharp adze and led the way to the far end of the island where the largest trees grew—"

"Ah", we nodded.

"Largest trees - alder, poplar and pine, that reached the sky—very dry and well seasoned so as to sail light for him in the water. Then, when she had shown him where the best trees grew, Kalypsō, the nymph that loved him and shines bright among the gods, went home, leaving him to cut the timber. Quickly he felled twenty trees, and adzed them smooth. He fastened together the timbers with bolts and rivets. He made the raft as broad as a skilled shipwright makes the beam of a large vessel, and he filed a deck on top of the ribs, and ran a gunwale all round it. He made a mast with a yard arm and a rudder to steer with. He fenced the raft all round with wicker hurdles as protection against the waves, and then threw on a quantity of wood" [12].

We looked doubtful. To fell all those fine trees just to make a raft, just for one man.

"He was escaping the goddess", murmured the little mountain ash, "she was *after* him".

"Ssh ssh, we don't speak of such things. Mm. Well, maybe. But we've never heard that one before".

The little buds hid their heads in embarrassment. They'd never heard of Homer's epic song, not even once.

"It's Greek", Kate said, indignantly, "it's ancient, *classical*".

"Um?"

"Homer!"

"Oh, um, Homer, er, yes". We looked at each other. If it was 'Homer' it must be all right we guessed!

"All right", we said "It'll do, pass on. The next?"

Five

"The next", we repeated, "surely you know some more".

Kate looked uncomfort-able, felt it too.

"Well, yes, but, but you might not like it. Not very, er, polite about a tree.

We looked round, gathering views. The beech tree nodded, ponderous.

"We will accept it, Kate".

"Oh go on go on with it", chittered the thoughtless sapling youngsters, all excited-mentioning, "Can't wait".

Kate drew a careful breath, and then -

"It's not about *you*", she said, "more about humankind. Them over there", she said.

<div align="center">"A Poison Tree</div>

I was angry with my friend;
I told my wrath, my wrath did end.
I was angry with my foe:
I told it not, my wrath did grow.

And I waterd it in fears,

Night and morning with my tears:
And I sunned it with smiles,
And with soft deceitful wiles.

And it grew both day and night.
Till it bore an apple bright.
And my foe beheld it shine,
And he knew that it was mine.

And into my garden stole,
When the night had veil'd the pole;
In the morning glad I see;
My foe outstretched beneath the tree" [13].

Six

And now. This is getting exciting, isn't it! Anyway *we* think so. Need more, though.

"A *proper* one, Kate. About trees, not about wood. And not nasty trees either, like ivy and such, *she's* not a *real* tree. Our enemy in fact".

 "Hush hush", soothed the cherry in its snowlike whitest blossoming style, " hush, let us be kind. Yes Kate? Sing on".

Kate lifted up her voice and sang. And the trees grew still to listen, the wind hushed, and the birds fell quiet, so sweet was her song.

"A tree that looks at God all day,
and lifts her leafy arms to pray;
A tree that may in summer wear
a nest of robins in her hair;
Upon whose bosom snow has lain;
 who intimately lives with rain.

Poems are made by fools like me
but only God can make a tree" 14.

We nodded in joy. That was more like it. Lovely in fact. Just one more now to go, it will be the best, surely the best.

All this fine knowledge there, all about trees. *Us.*

The seventh

The mighty voice come through on high.

"Yes Kate, well done. Six spoken now, we-ell, just about. Just one more now, to make up to seven".

"Seven! but you never *said* seven, that it had to be seven, how can I possibly … Seven, really seven?"

"Seven".

"No no. If you said seven I didn't hear, no I didn't", Kate trying not to cry, "Did *not*".

"Of course you heedless girl, seven prime number beautiful, the faerie one, seven seas, seven stars in the sky, seven wonders of the world, seven seven, seven seven of everything, you must know that much, even you. Until you've given us seven you may not climb, climb up to him, you may not go on your way to find him, No. Seven or never, never or seven".

She couldn't.

Impasse. No pass. Now no more climb to find-en seek-en him.

The larch

Kate wept and cried and hugged the trees and refused to move.

"Go home", she heard the stern voice say, "it is finished for you".

She cried all the more and sobbed and fell on the ground.

We closed our hearts, was hard but was the lawl

But one tree pitied her. The one that is not afraid to stand alone and differ-ent, different from all the trees that grow there in the woods. Not like the trees with leaf-shaped-leaves that shed them on the ground when autumn comes. Not like the pine-green-spikes, the needles ever green through all the year. Not like the saplings growing slow by centuries. But standing proud and beautiful, god in its heart. Not to be climbed. No no, but pity-full.

It bent close down to Kate, a whisper in her heart to help her on.

"Remember the larch's song", she felt it murmur to her then, "the magic seasons of the larch, so ever beautiful".

And so Kate sang.

"Spring of the year
of youthful'st love
of springs abounding
here above
the earth, the heavens, oh worldly sweet
Oh dear'st delight
The softest sward of loving firsts
of larch and birch
and greenest leaf.

Oh then the summertime –
The season sure of love and marri-age,
for children meet, for family
grandchildr'n then, and then the prize
of pen and sword".

Her voice quavered and quivered and wavered. It was hard, she was afraid.

"Her voice isn't really up to much", we said to each other, we said, we the trees, "It needs the tempered wood of an instrument to make it fully sweet. But", we looked around, "Let her go on. For the trees help

those who help themselves".

So we nodded to her in unison to help her sing. We wanted to hear the end. *Specially* how she'd sing about autumn time. The goldening arrow-ed-springing leaves-not-leaves of larchen trees.

We listened. And she sang, completing it.

"And then the fall
of life, of season
callen back by ageing bone
But f' now we walk again
Your touch, your arms enfold
not springtime's loving now
but autumn's sweeten'd gold" [15].

Was it enough? Not what we'd expected first.

But

 - as the tide sweeps over the flat sand of the shore

 - as the wind blows unseen through the trees yet makes them bend

 - as the light creeps up from darkness to flood the world

So is the mercy of the woods.

- as the pearl rises from the grit of the ocean, from the

dust, the dirt

 - as the shell nurtures it like the seed of a lovely tree

 - as for every thing in earth and heaven and in the great garden of the lord

 - as there is a season, night as to morning, moon as to milky way, dawn to limpid dusk

So is the mercy of the woods.

"Pass on Kate", said the great voice from above. And from her heart.

"Pass on dear Kate on your quest", we said, "and climb for him, nought now to fear".

PART VI THE SEARCH

To finden him

But - that -

That all very well - beautiful poetry and all that, but poetry not practic-al. She still must search and find. And tell him. If she dared. That, that -

Well, find him first, and *then* …

So find a tree. And try. So many many there to climb.

The oak tree spoke. "Listen first so you may know, In my being I have a world, a …".

"But then a storm, and you all fall down", interrupted. the silly-sally sapling. Cheeky. Ignorant.

The oaktree paused. Then he looked at the young tree, stupid one, in kindly wise.

"Do you not know my child that therein, yes, therein in very truth, there lies the secret of the trees. We seem to die. But no we are alive, regenerate. We are burned - we live again. We are tossed in tempest and

uprooted, all - and in those fallen limbs the seeds of new living life. Another wood".

The sapling was impressed, even him.

"Was that how *I* came about?", he whispered low.

""Yes, oh my child, it was", replied the mighty oak , "from those green shoots. Is not God good?"

So then

- as the moss grows silent in the hidden creeks of the trees

- as the flowers open their petals to drink in the rain

- as the tide creeps gentle over the barnacled rocks

- as the spring leaves come before we know

Even so we all fell silent, we listened to the wind lapping quiet through the wood. We were not certain about the "God" idea but knew the earth nourished us in her living hands. It was good.

Yes good, thought Kate, yes good to know, But it didn't help her on.

So many trees. She should try them all. In case. *Which* had he climbed?

She tried the stern blackthorn with its cruel spikes and snow-burst flowers. Too sharp. Laburnum of yellow-flower profusi-on, but poison pod. Spring flowering, magical, magnolia, prunus, almond flowers - those miracles. Alder and aspen, and sally by the brook. Fruit trees growing wild or helped by humankind - of damson, fig, plum and mulberry, and more besides. Sweet smelling balsam, maple, lemon tree. Banana, coconut, and palm tree, drink for climbers, sweet.

"And vines?", asked Kate in case we were listening still and helping her.

"Hush, hush", we said, "no, those you may not climb".

"Why not?", began Kate. "Oh well, then", pushing her luck, "there's bamboo, sugarcane".

"No no", reproved the beech - he had great learning and could read - "they're *grasses*, they're not trees".

We felt reproved, astound-astonish-ed. But the larch tree checked it back - she always tried - and he was right. [16]

Kate listened, and no doubt, like you, she learned.

But learning was not what she was after then. No no, not Kate. Wanted only to search and *find.*

But however hard she tried, she could not climb them all.

For -

There is an infinity of trees. Trillions on earth. And many more in heaven.

She knew, somehow (a voice within?) that she must climb and climb and climb them *all* to find him, scary that - so she must grip her courage fast.

But all? Impossible.

Oh well, just do her best.

Which try?

Think think!

Just *which* tree had he climbed?

We leaned down low and whisper-ed.

"The sweet-nut mottled gentle hazel - ever kind, and not too tall. Try there. The first".

Kate ran over, eager of eagerness, put hand on trunk.

The branches barred her way.

"But Kate, oh Kate, do you not know the charm that you must sing, the right and rightest hazel spell to make it bend and sway into your grasp?"

"I don't", she crossly said.

"Just think. Look in yourself".

SILENCE

For Kate now surely it was the end. No love for her.

The climbings

"Remember … when you were little your mother sang to you "Let us love … ".

"Oh oh yes".

She sang, remembering

> "Let us love trees with every breath we take
> until we perish".

The hazel spread out its branches wide and Kate took hold to climb.

Climbed. Climbed climbed climbed to the very top.

He was not there.

What next? Apple trees were from the genesis of the world, not so? In the Garden, Eden, Nirvana, Heaven. Surely he would be there.

She looked at the gnarled and crooked age-ed tree, only some wizened apples hanging there. Oh there she would find him, tree deep in ground with a snake below. She would pick the best one, give it him, he would be waiting there for her, sweet from the earthes first beginning. That she would pick for him.

The charm came to her.

"Even if I knew that tomorrow the world would go to
pieces, I would still plant my apple tree" [17].

She climbed, first crooked creaking branch, then
thinner slighter ones, then twigs, then open air.

He was not there.

We all fell silent and looked to see what she would do.

The olive tree bent her head and softly spoke.

"I remember I remember", she said, "one day by the
waves of the deep Aegean Sea, a boy sat under an
olive tree, my ancestor it was. 'What are doing?' she
asked, Eurydice. 'I am shaping this sweet wood,
wood I am freely given, to make a lyre'. And so he
grew, he Orpheus, the greatest singer-songster of
those old days, now too perhaps. Without me, never
would that have come about?" [18].

The other trees wanted to say she was puffed up,
exaggerant - but they couldn't for it was true.

Yes, an olive tree. Must climb. So smooth, so
beautiful, so Odyssean too[19], so resonated echoed
wood-'nhanced lyre'n music and the fruit of love.

The fruit of love - so surely this was the tree to climb, to find him there at last.

She climbed.

He was not there.

Kate wandered on, distraught.

She came to the foot of a mighty upright single trunk. Looked up. She could not see the top, just a golden-bark-ed stem, dark pine-ed spikes, and climbing branches up above. It was the highest mightiest oldest of all the woods, and of those that grow today.

That height, that age - she would surely find him, him, her life. Himself.

She tried to climb. And tried again. Was not allowed. The branches moved and curbed her way,

"The charm the charm, you must say the charm" we told her, "quick".

"Oh, but I don't …" began Kate.

"Oh think Kate, think, go deep inside. Yourself", we said.

So Kate lifted her head and spoke in an echoing song. For herself. For him. For the lofty pines that inhabit, populate our precious world.

"Between every two pines is a doorway to a new world".

And lo - two trees were there, we're twins, and between them Kate now made her way. And upward climbed.

He was not there.

A cedar? Surely something fragrant, special there.

And beautiful. Listen, her leaves are whispering you her spell.

"Our aery buildeth in the cedar's top,
And dallies with the wind and scorns the sun.
And turns the sun to shade" [20].

"That's lovely" said Kate, " 'dallies with the wind'. I will climb to your aery top and find him there, in perfume sweet, I know I will".

She climbed in joy, in confid-ence, she smelled the wind-borne scent.

He was not there.

Oh she was stuck, could not climb down again. Was terrified.

"Stuck? Move your foot up, down if you prefer, next hand hold, go, go on!"

 "I'm stuck 'cos no more trees for me to try".

" You've forgotten the holly tree?"

"Holly? No no, impossible, those prickly piercey thorny leaves, catching scratching me. You don't *climb* a holly, everyone knows that - beautiful to see but not to climb".

"Look up", we told her, "up. She has to have prickly leaves below, 'gainst creatures that would eat her leaves. But at the top where the birds come to pick her berries - for them enough, enough for us, enough for the world at Christmas time - the leaves are soft and thick … you will find them there. Climb climb".

She looked but did not move.

"Hard at first Kate but worth the pain", we told her straight, "do you not know that of all the trees in the world the holly bears the crown?"

"Oh, all right when you get there", said Kate sulkily, "but what about the first bit? I still say impossible, imposs!"

 "Listen then, don't you know?", we sang to her

"The holy bears a berry
as red as any blood
and Christ was born on Christmas morn
to do us sinners good …

Oh the rising of the sun
and the running of the deer,
the playing of the merry organ,
sweet singing in the choir" [21].

"Well I suppose I *am* a singer", said Kate, "sort of, but I don't have an organ of beautiful wood, and anyway I can't can't can't climb through these horrid prickling leaves".

"Climb up on me", whispered the birch, "a secret, climb up then step across when you reach the top and see the holly's soft leaves, and there perhap perhap you will find him".

She climbed.

He was not there.

The infinite of trees

And so through all the length of days, of million million years she climbed, she failed.

She climbed, she failed.

She climbed, she failed.

Glad would we sing them all to you, and celebrate the trees, the woods. But time forbids. Too many for e'en an inspired poet, e'en Homer-taught.

A million trees. No, more. Infinity plus one.

A million words, oh infinite, spilled in the monkeys' type.

Even they could not strike the mark.

So many trees. Now Kate had tried them all, well almost all.

She'd try again, begin again, go round and round,

But, but, she was afraid, the trees so high, was tired now, first steps were harder now, impossible, the trees had grown taller in those centuries of years, she could not reach.

She tried tried tried. Arms too too short, she could not

do it. No one to help.

No good. Just close her eyes, give up.

There

What's more than infinity? Kate useless at math-reck'ning but "infinity", she knew, was far beyond it all, beyond all *she* could do.

A little bird, friend, look, was hopping there.

"Look up", it said.

And oh what profusion, riot-crown of flowers. The cherry blossoming above, around them all.

"Oh look", cried Kate. Distracti-on. So beautiful.

"Why do you not climb?", said the little bird.

"No no, too beautiful. Beauty not truth. Not seri-ous".

"Beauty *is* truth", we said to her, we, we the trees (we knew, *we* had read it too [22]).

"Maybe a *little* serious then", she said. And closed her eyes again.

"Do you not know", we asked, "The cherry tree's sore task? In days of old? And then, now too?".

"Dunno", said Kate, knew now no good.

We felt her ignorance and said to her, quiet, in bach -en sweeten unison.

"Oh sacred head sore wounded
Despised and out to scorn
Oh noble head surrounded
With mocking crown of thorn" [23]

"Thorns", interrupted Kate. Rudely. "Cherry trees don't have thorns".

"Ah but the cherry tree in ancient time bore one with piercing thorns around his brow, to mock at him. By humankind, not us".

"A *cherry* tree, something serious on a *cherry* tree? Oh nonsense you!"

"A cross and a scaffold are made of wood" [24], we quoted solemnly to her, "is that not serious?".

That made her cry, too sad. "It's time to die", she said, "I'll never find him now, he's gone".

She lay down. Was no good. We tried to sing, In sympathy.

"Be near me lord when dying
Oh turn not thou from me
But to my succour flying
Come lord and set me free.

And when in death I languish

In that last fatal throe
Release me from my anguish
By thine own pain and woe" 25

Kate opened her eyes.

"Maybe a little serious", she said, "if it's dying".

And closed them again.

"You *could* try to climb again", we said, "even among the flowers, even in that sweet fragrant scent".

She opened her eyes again. Last time?

"Maybe", she said, "but I don't know the charm".

"We told it you", we said, "think *wood*".

"Cherry wood, cherry furniture, cherry lutes, cherry houses, cherry … Oh shut up, don't know".

"Crucifix-cross", we whispered reverent-ly (except the silly-sally sapling, rascal lad. No reverence there, so just ignore. He'll grow).

"Maybe", said Kate again, "if the cross and the gallows are made of wood, and the ladder to hell and heaven of wood too, three ships a sailing in with … Yes. I'll try. I'll climb".

The cherry tree bent down and smoothed its flowers

and made a way for her, for Kate, the trysting trusting trying one, The-Seeing-Seen, The-Seen-By-Us, the wood-growing trees.

And the perfume filled the air around.

The last?

Was the cherry tree her only answer now? Yes, it must be, for her. Surely. At last.

Just one more foothold, one more stretch of an upward hand.

Then, then, yes then, he'd be there, they would enter heaven together. Now. As one.

She'd tried so hard, eternal years. But now at last - ?

It was the chosen end, their mutual paradise.

And yes she saw him clear. In the next tree.

Not cherry but - another tree. A mighty strongest one. Her heart leaped up. Was him, was truly him.

She could not reach.

Despair again, worse than before. The very worst that could befall in all earth's days. Or universes' ways. She'd been so sure. So climbing, fearful, frightened, 'fraid-en-ed.

Let go, what else.

She fell, again. Slip-sliding desperate-grabbing down

Despair.

The last, the strongest, best

Stopped just in time. Clung on. Then climbed again.

Climbed *up.* Again.

Just one more try. She looked around with blearing eyes.

Surely that was the oaken tree just over there, king of the wood, that he held onto? *He*! Tree she must climb to reach to him?

Not cherry tree, but *oak.* The mightiest strongest sturdiest steadiest tree of all. Easy to climb or not, well, Kate would try. No other left.

She knew its secret too, that saying of old, that wisest lore.

"The creation of a thousand forests is in one acorn".

But - it was hard. First branch was out of reach. Too high, not benden down in kindness-wise for Kate.

She tried to leap.

Too high.

No good.

She tried the friendly hazel branch and leaned across.

Too far.

No good.

She stood on a heavy lugged-there stone.

Too slippy.

Oh, no good.

Give up.

"No no Kate, look around. Look there, there at your feet".

She looked.

"Look round", we said again,"look there, behinden you".

And yes - the movement of that mighty oak. Gigantic, lofty, tall, thick trunk, the heaviest branches of all trees of heaven and earth.

What was he doing there, that lofty one?

Kate watched him lay a mighty branch across the ground, right down, down there before her feet.

Rough barked it was, and knobby, gnarled, dark blackish brown, nests for the birds, and insect holed, with busy spiders running round, oak-appled acorned, mossy crooks and nooks and handholds firm.

Kate saw the mighty limbs move quietly down for her, humbling themselves before her feet. Or was it centuries before, millenni-a, that she was there in aeons-old tale before that time? Ah yes, remembered now? [26]

"Oh oak great oak, have you done that for me? Or for yourself, to rest your aged bones?"

It was enough. Kate climbed. Was easy, clambering along, then gently up. The oak tree seemed to help, to want.

Up with her hands hooked round, she climbed.

And climbed.

And climbed.

Now she was near to heaven.

Right to the topmost twigs,

And - he was there.

PART VII THE FOUND-NOT-FOUND

Would he?

Ah ah, she saw him clear. Atop the tree (was it the tree where a girl had left him once and galloped off?).

She climbed some more. Now he would stretch his hand to her!

She'd come so far, she'd helped herself, she'd trusted him.

He knew, would surely know, that she was sorry sorry sorry. Sorry that she had run, before. Had heartless, frightened, fled away, abandoning. Before she knew, knew all her love, that burgeoning swelling volcane cyclone love. Of hers. For him.

In joy, emoti-on, she sang the song she'd made for him. So long ago. In confid-ence of love. In metaphor.

"If

If I should go, say only this to him
that as I went I thought of him
that I died loving him
and that I would wait
there
by the gate, of heaven.

that we might enter in
as one ..." [27].

She stretched up her hand to meet with his strong grip. In utmost joy. She knew 't was right. The destined end. At last was safe.

He caught her hand in his, it was warm and firm, yes steady, strong.

Yes yes, she was safe. After all those centuries, those climbs, those tears. Was safe at last.

A thousand sighs and tears and smiles were not enough.

But she had climbed.

Was safe at last.

And then

Then -

She felt the hand slip from hers, had he let it go?

Yes, let it go, he, knowing, let it go, he pulled away, let go, deliberate,

Deliberate.

How could that be?

Deliberate.

She felt her falling self, her on the ground, looked up, his shadowy silhouette above, moving on, on, on, next tree, then next, then gone 'way 'nto the sky.

And gone.

PART VIII LOST

Alone

And gone. She was alone.

Was left behind.

Alone.

Deliberate.

She was left. Alone. Lost.

Nowhere to gol

Fall'n on the ground. Abatter'd, bruise-ed, fall'n and fractur-ed by him. Alone

Alone.

"Ah Kate", we said, tears in our eyes, "you had forgot. Was not the poem called 'If?' Did you forget the ending lines?

'If
If
If
If you should want' [28].

"He did not want".

She was alone. No green shoots for her sobs, for the trees, the woods. Alone in the dry dust. Waiting for - oh for nothing now, why wait? But what else could she do?

Just wait, just wait …

She was lost, lost in the woods, what else but wait. Wait wait for nothing to happen, to come.

And worse - he'd pushed her there, not wanting, hating her. For all she'd tried to do. For him, for him, just him.

Alone. Abandonment.

And he

So he was there, into heaven, now. He'd climbed the highest tree, near'st to the stars of all earth's living things. Now he was in the place of paradise nirvana eden *tir nan og,* of fairyland and shangrila tranquillitie.

There he'd stay gentle safe for ever, lulled by the sounds of the distant sea and wind-blown trees and resonating wood-carved instruments.

Oh peace at last, in evening celestial-time. Look down on the topmost twigs and on the earth and all below.

Oh no!

But - *where is Kate*? Did she not climb?

Did she not dare, not *want?*

Kate, where is Kate?

He took his heart and looked it in the face. Not easy it was, but he saw -

He saw he had let her go, let slip her hand, forgot and climb-ed on himself int' heaven. Deliberate.

Abandoned her.

"No surely not", he cried, "not that, I did not mean ..."

"You did", the great voice said (himself it was).

"It was *her* doing, she let go, she didn't hold, she didn't really want to climb, to come, to persevere, to be with me".

" You think?"

"We-ell...".

Sudden he realised what he'd done. Abandoned, killing her perhaps . Worse, broken her heart and turned her down. His Kate.

He looked far down, far far, searching for her beneath.

He could not see her there.

For she was covered in the dust, dry leaves, the dearthened darkened waterless earth.

She was waiting, just waiting, what else, just waiting there, waiting for one she knew would never come.

"I will go back for her", he said.

The voice - himself? - reply-ed unto him and spoke in firmest words.

"Once you climb down that oaken tree, or any tree, you will never never never enter here again. Surely you will not think of that, of throwing away your paradise?"

But he? Now sturdiness, decisive, *him.* Knew that he must. He loved.

"I *will*".

"Once only can you climb to enter here. It is the rule. That I, even I, can never alter, change, disrupt".

It was hard. To lose his heaven, his paradise, his home, his ever-calm.

But - she was Kate.

" I must".

Farewell

He swung to the nearest branch, a twig to bear his weight (or not). Was gone.

 We heard the mighty voice's *smile, and* sweet it was.

"We'll see", it said.

The plunge

Going up had been hard, so hard. But going down was harder still, impossible it seemed.

But go he must.

Oh how? And where? So many trees.

He tried to plunge quick, hasty, down. No finessing or carefulness, just letting go. But somehow did not fall.

He knew, remember-ed, yes that was it:

"If you climb up a tree, you must climb down *that* tree" [29] .

So find the same tree that he'd come up, answer to his wonderings.

But - was this right? Maybe, for him, *this* tale, not true?

He tried to slither down. The tree forbade. No handhold foot-hold, no way through. He reached out far far far, was dangerous. Lurched to the next tree's trunk. Held on with trembling weakening fingers there.

Ah yes, was now three inches down. Lower. But that was it, he could not move below. Was still high up,

and far far far, then further still, from where Kate's too silent body lay.

So reach again. Few inches down. Oh, still too high.

Then try again.

Again.

Again.

Reach reach and reach.

Three inches down, must try some more

Again.

Three inches more, so climb again, more inching down.

Was very long. Thousands of trees. No, around the earth are million billion trillion trees. And more.

For centuries and more, millenni-a, he climbed. Before the dinosaurs were on the earth or meteor-strike, or birds evolved. So long-time down he climbed. Would not give up.

And Kate - she was waiting waiting waiting in the dusty dry crinkling dying leaves. Not thinking he would come, would ever come.

Searching, searching, searching

Still not on the ground. Oh how to go get there and find?

But now he'd come right round, around the earth, was slipping down on that same tree that first he'd climbed.

Now at last he was nearing to the ground.

And then he heard, heard the small sob plainting, crying sorrowing. Sad sound but for *him* the utmost joy. For there was Kate, he heard, oh surely her.

But how to get there, reach? Was still not *quite* on the ground.

He shut his eyes.

But sudden - he was there, there in a sweet soft glade in autumn time, gold leaves lying crunched and dry. And a figure lying there.

It did not stir.

Oh selfish Kate! He was *angry, justified*. He'd come all that way for her, and laboured, Eden-sacrificed. And she did not even *look* at him and thank him for his braveried endurancing, it was all for her, for

centuries, millenni-a, of painfulness. It was too much, his anger was too right.

"I'll go away. No good".

But - Kate has opened both her eyes. She smiles at him with gentleness. And the tears roll down her cheeks.

His too, relief, all anger gone.

"Now we can enter into heaven as one ", he said, "for now at last I have found you here. Not galloped off. Not letting slip your hand. Forgiven, both".

He helped her stand and helped her put her arms around the tree. That same oaktree it was where first he'd climbed, that one too where she'd gone in her mother's womb.

But they could not start. That tree was not prepared to let them to climb.

PART IX BACK WAY TO THE SKY

Around

"Now I will take you to heaven", he said, "we'll find a way".

"But I'm not able to climb that high", sobbed Kate, "I've tried and tried, for me it does not work. You go alone, yourself. Just leave me here. I know now that you love me, and forgive, that is enough, what other heaven do I need?".

"I have heard", he said, "that for some, mayhap for you, the truest lastest way to heaven is back, behind, beyonder way. For me, the straighter way, but still a far way, round the world, the little-by-little clambering way. Like I came down to find you here".

Kate looked at him. Had he really come? For her? Wanting *her*?

"Come now", he said.

He held out his hand to raise her up.

But still she could not climb, knew not the way of it. And was afraid. The height. The falls.

She looked in his eyes, then looked away. No good. It was farewell. Together, greeting, then farewell.

Then spoke a little bird that was hopping there, of wisdom he, in words they understood.

"To reach to heaven? Remember again. The back way you must go, not straighten up by plain pathway. Must go behind, beneath, back way, by root to root and tree to tree to tree again, to reach-en heaven.

'T was strange they understood bird-speech, the trees as well (but maybe not so strange, for in these olden days was much of magickness, communicating-ness [30]).

"For me", said Kate,"I see it now, the way is *down.* Must be".

He shuddered, hid his eyes. But then bethought himself that she had wisdom too. She knew the way. And perhaps, perhaps - one day …

And their eyes locked. Then straightway Kate felt th' earth move beneath her there. Down down, now down she was, among the deepest tree-ens roots, the roots of that great oak that had shaded her before.

Down down she sank, to the smallest roots, mirror of those small twigs on high. The necessary roots that lie below (as for us all).

Amidst these now it was that she must find her way, then up and up at last, through hours of climb, and days and months, years centuries, millenni-a. And many lengths of lives, and tales.

To the upper air, then climb again again through trunk and sap and branches, twigs and topmost crown.

She went, climbed, trembled, dared.

She was afraid but not afraid for she must go. Her destiny. Because she knew that he was there, was waiting there, for her.

To reach?

And so he was, she saw him there, atop the high high tree, there, just across from her, same height. Twin trunk.

She could surely reach - but the tree swayed away from her, the gap too wide.

She clutched on tight. Was needful, the ground was *far,* far far below. Far far, too sore, if falling there. Too far. Was terrifying, don't look down!

She looked across to see his smile, might help. But the leaves fluttered in the wind, were hiding him.

The leaves swayed back again - oh she could see him now. Wanting her? Or not?

Not if she did not come to him. She knew.

She knew that she must somehow reach across. And come to him.

If not - no good, no good, he would never want her again.

"Oh Kate", we called, "have faith. Faith can move treetops, mountains, human hearts. And daring too".

She did not hear. Not listening, but wondering in her frantic heart.

Wondering if she could leap? Perhaps it was not too far?

Oh but she could not do it, dangerous, she did not dare.

She did not dare, she did not dare, she did not dare, not dare.

Even for him.

It was too high, the ground too far, no one to catch her, no birds to help, too high she would fall she would slip slide tumble sink slide slipping down on down past the tearing twigs and thorns and piercing projecting points from the barkened roughen'd tree trunk down, down to the earth. That was worse than hell, oh worser, and now she could not hold she was wobbling, slipping, going to fall.

He watched her, heart in mouth. Too far it was for him to reach, to help her cross. But he saw, awaited her, was confid-ent. That she could come. Oh surely come.

Was still that separati-on, he on the tree, the twin tree, near but far, the high-up branch, she hesitating, separate from him. Not yet the happy end. Still love denied.

Only one way to solve. If she dared to jump.

But she could not. Was there on tree, so high, so juddering, just trembling, there. Marooned. Aloft. And terrified.

Kate looked across. He was still there, clinging by one finger's hand to the oaken trunk, smiling across at her.

"We can go in", he shouted, calling her. "We can tread up along the highest branches, twigs and enter heaven as one. If - if- if … oh if you dare. And *leap*".

He held his hand out, out for reaching her, the other fast to the tree to keep him safely there. Was needed. Too far to reach her straight.

"It is all right", he called, "for you can leap. I'll catch you, easy, only a little way".

Yes little, short. But -

She look-ed frantic down. Oh panic. Greater than height of the moon from the earth.

She was afraid.

"Leap now", again he said, "for me to catch".

She was afraid.

"Leap now", he cried, aloud, then louder still.

"Leap now", whispered the oak, the very oak whereto she held. She quavered quivered, quaked and clung.

She was afraid.

We understood her fear, even we the trees. But knew that she must dare.

And still he held on, fast to the branch, he was watching her. Seeing if she dared. Waiting. Hoping. Waiting.

Waiting.

But then he saw that she could not. It was too hard.

It was for *him* to act. If he lov-ed her.

He did.

What could he do?

PART X THE DARING

The possible-impossible

He looked again, across. One hand clung on, clung fast (was needed, high so terrify-full danger-full hazardous high). The other fumbled with his belt. Aha, his knife!

"The back way indeed", he said, "the one we did not know. The one that I must dare. Will dare for Kate".

Thus clung on he atop the highest tree. Near her. But not enough.

Thus clung on Kate, trembling with fear and fright, knowing she would fall. And heaven so near. Him on the next top tree. Too far for her to reach, for her to jump.

" Leave me oh leave me here", she cried, "oh save yourself, go on to heaven, you will be happy there, just leave me here on this beautiful tree, with a bird to be my friend and sing to me. Save, save yourself".

He reached his arm across t'wards her. It was too short. Again. He could not reach.

"Jump jump sweet Kate", he cried again. But she could not, did not dare, it was too far, too danger-panic-full.

"Jump jump dear Kate".

She dared not, was afraid.

He called again, in desperati-on.

"Jump jump dear Kate, I cannot come to you, the twigs too weak, they would not hold my weight".

He looked again at the tree whereon he sat, at the very branch that was holding him.

His knife!

He tugged tugged tugged, it came, he held it in one hand, the other fast to the branch (oh needed still, we knew, was danger-full hazardous-high).

At last, he knew, he looked hard at his knife.

It shone for him.

- as the full moon glows above the earth at eve
- as Sirius glitters in the morning sky
- as the sun sparkles in the sea and the frost

So did his knife shine there for him. And his eyes too shone, shone with a hero light.

"If I cut above me through the branch", he said, "for sure I'll fall but if I'm quick enough I can reach out to her, bring her across. And the lighter branch above, still there, will hold her lightsome lissom weight, she'll reach to paradise. And I? Oh then - what matters if *I* fall".

He cut.

Down down and down

The branch dropped 'way from his clutching hand and down down down it went. Kate heard the sound - it was his body, sure sure sure, she felt it, heard it, knew it, bouncing bang bang bang and CRASH on the ground, one bounce, lie still.

Was *him,* was surely him. Farewell.

"I will jump after", cry-ed Kate, "in death we will be together, that is heaven too".

She started to let go. To be with him.

Farewell to both.

"Oh oh that sacrifice-sacrificing sacrifice", we cried, "to *wound a tree*, a living tree. To bring about mere *human* happiness. Even for Kate. She surely would not wish - . To kill a branch, a tree's dear limb, a living leafing loving branch, it is not right".

But then we thought again - more sense. It was *not* the end, we knew it when we'd thought, for us, for them.

"Oh listen now dear saving save-ed ones", we called. Do you not know that this is the love of living trees.

For ever more, eternity and more on th' earth, the living sounding tree-en earth, always we live, will live, regenerating full. So too for you, regenerati-on. And life".

Kate heard it with her harkening listening ears. And accepted, pondered it. And understood. For she deep lov-ed us, the trees, the wood, the sweet voiced music reverberating there, in wood-formed 'nchanted echoing sound.

"Take heart", she heard the call, "Can you accept the sacrifice he wished to make? To die for you?"

We saw her nod, eyes closed in agony. She thought him dead.

"Look down", we called, "look down. It was the branch that fell in sacrifice, not him. He is alive. Now dare for him as he was prepared to die for you. Leap now".

"Jump now", we cried, together, urgent-ly, "Jump *now*".

Kate shivered. Thought. And first, the foolish girl, looked down. Was worse.

She knew how it would feel. Too vivid clear, was real, too real (was real to her, that moment's time).

She held by one finger tip. Slipping by now.

She closed her eyes. It was the end.

We called again.

She jumped.

To dare

She felt the air slip past. Was she going down or up or east around the world through million years of eternal life.

She kept her eyes fast shut in terror. Going around the moon or through the outer galaxies? She did not know.

Ah she would go further than that to be with him.

She look-ed down.

There were her feet on that same branch whereon she'd been, hands still clutched fast to where she'd climbed.

She had *not* jumped. Not dared it after all. In her *mind* only had she jumped. Imaginati-on.

"Imagination, that is the needed start", we called to her, "now follow with your *will*, that will be enough, will carry you".

To leap again.

She summoned up her will. Was hard.

"Come come", he called t' her, wobbling, holding on.

"Go go", we cried " yes yes, you can. Just jump".

She did.

This time she *really* did.

Aah!

She landed lightly on the branch above where he clung fast, heart in his mouth a-watching her.

Would she fall, slithering down?

Would she mount to the sky, leaving him there?

Would she fly off through the air, away from him?

No, she was *there*. Wobbling, afraid, unsteady. But was *there*.

<div align="center">With him.</div>

And so she smiled, smiled in his very face. Then turned to *him*, she'd crossed the gap between and - well, was not so much a smile as a cheeky grin. For she was Kate, Kate The-Seeing-Seen, The-Thinking-

One, The-Seen-By-Us, by us the wood-growing trees. The heroine, the one that had dared.

She stretched down her hand to him, now it was *hers* that reached, it was firm and soft.

She pulled him softly up to where she clung.

So now he stood steady on the topmost branch, by her. And smiled at her.

Along the corona of trees, our crown, they trod together, in an infinity of blessing, of startle-happiness.

We saw them step lightly into heaven in the sound and scent of us, the trees.

And as a great tree falls but new shoots live again, so they stepped into the sweet light-dark, the dazzling dark of heaven, as one.

For when she was most afraid she had dared, she had leaped.

For love.

Ending

Now the darkness is lit, the deep wood is alive in the sing if the burds, lit by the sweet shining pearl. Because? because she had leaped, she had dared when she was most afraid, when it was hard.

So

- as the woods fall in the storm

- as the trees blow down and generate

- as the great boughs break and fall and lie on the ground

So does new life begin. Continuing.

It is the way of the world, the woods.

And of the human heart.

We give you thanks oh Kate, from the trees, from the wood, from the human-lived earth.

Kate who sees the living ones, the trees, the wood.

Who lives among us for ever

whose love lightens our darkness

in the deep wood of life

The pearl.

Epilogue

We saw it, we the living ones that never die, one cycle of life handed to the next, eternally.

We see it now and for ever

The pearl shining through the trees of the deep dark wood

The pearl that shines for us all.

If you enjoyed this …

Here are some other books you might like

 Earlier volumes in the Kate-Pearl series (2018-2023)

 Pearl of the Seas, a fairytale prequel to The Black Inked Pearl, Balestier Press

 The Black Inked Pearl, a journey of the soul, Callender Press

 The Helix Pearl, the tale of the wine-dark garrulous sea, Callender Press

 Pearl of the Wind, Callender Press

 Fire Pearl, a tale of the burning way, Callender Press

 Nonfiction works by Ruth Finnegan that you might find of interest

 Why Do We Quote, The Culture and History of Quotation, Open Book, 2011

 Time for the World to Learn from Africa, Balestier Press, 2018

The Hidden Ordinary, Reflections on the World,
Callender Press, 2021

*Communicating, The Multiple Modes of Hunan
Communication,* Routledge, 2013/2023

A final plea: indie authors are especially dependent
on reviews for attaining publicity. so if you enjoyed
this book (or, equally, if you didn't), it would be hugely
appreciated if you placed a review, however short, on
Amazon.

I am always delighted to hear from readers at
www.ruthhfinnegan.com/

Author's Notes

[1] I have not added explications for allusions to issues or events topical in 2023 (such as concerns over "he"/"she","men"/ "women"; emergency medical staff and their strikes; or "spare" heirs). They just happened to float into my mind at the time but are not important - readers may or may not wish to recall them.

[2] A translation and adaptation of a story recorded in Sierra Leone, West Africa in 1961 (the full tale can be found in Ruth Finnegan, *Limba Stories and Story-Telling,* 1967).

[3] Simile adapted from Homer, *Iliad*.

[4] Simile from Homer, *Odyssey*.

[5] From Kate's *Blackthorn Poems (*adapted).

[6] The awe-inspiring soaring cathedral in Christ Church, New Zealand, built after the devastating 2011 earthquake, is famously "made of paper", looking and feeling like wood.

[7] When Kate was little her mother had read her long passages from the wonder book kept on the cottage highest shelf, the *Wiki Book of Marvels*. And because Kate could not yet read she *remembered*, and spoke it true.

[8] An Ancient Greek saying meaning "Know thyself".

[9] Poem by Robert Frost.

[10] "November night", by Adelaide Crapsey,

[11] Lines from "Birches", by Robert Frost.

[12] From *The Odyssey,* the classic Greek epic by Homer.

[13] "A poison tree", by William Blake.

[14] "Trees", by Joyce Kilmer.

[15] Of Kate's own composing.

[16] Despite their tree-like appearance, these are species of grass (see David Campbell Callender, *Grass, Miracle from the Earth*).

[17] Attributed to Martin Luther.

[18] As retold in the screenplay "Orpheus with his lyre", after the ancient Greek myth and Shakespeare.

[19] A reference to the scene in Homer's *Odyssey* when, after a parting of twenty years, Penelope cannot believe that Odysseus is really her husband returned, until he reveals their secret: that he had fashioned their marriage bed from a living olive tree so that it cannot, as she had suggested to test him, be moved.

[20] Shakespeare, *Richard III*.

[21] From a popular Christmas carol.

[22] How the trees had come across Keats' *Ode to a Grecian Urn* is unexplained - but those were magic times.

[23] Words of a chorale set to music by J.S.Bach in the *St Matthew Passion*.

[24] It is sometimes said that Christ's crucifix was made of cherry wood, thus making the cherry tree an object of special veneration, reflected in many myths and carols.

[25] Again from the *Matthew Passion*.

[26] Kate was right: when large trees age and their branches become heavy they slowly slowly let them rest, and continue growing, upon the ground. She had seen how slow this was when she went back to the gentle wood where she had spent her childhood - even after eighty years of human life the centuries-old oak branches, flourishing across the ground, looked to have changed by not one inch.

27 From "If", *Kate's Blackthorn Poems.*

28 The concluding lines of "If" in *Kate's Blackthorn Poems,*

29 African proverb.

30 For a wider perspective on communication see Ruth Finnegan, *Communicating, the multiple modes of human communication,* 3rd edition, 2023.

Ingram Content Group UK Ltd.
Milton Keynes UK
UKHW051106140523
421705UK00003BA/3